PORTABLE
COLOUR ME
HAPPY

Quarto is the authority on a wide range of topics.

Quarto educates, entertains and enriches the lives of our readers—enthusiasts and lovers of hands-on living.

www.quartoknows.com

First published in the United States of America in 2015 by Race Point Publishing, a member of Quarto Publishing Group USA Inc.,
142 West 36th Street, 4th Floor
New York, New York 10018
Telephone: (212) 779-4972
Fax: (212) 779-6058
quartoknows.com
Visit our blogs at quartoknows.com

10 9 8 7 6 5 4 3 2

ISBN: 978-1-63106-182-0

Library of Congress Cataloging-in-Publication Data is available

Printed in China

This book provides general information on various widely known and widely accepted images that tend to evoke feelings of joy in individuals. However, it should not be relied upon as recommending or promoting any specific diagnosis or method of treatment for a particular condition, and it is not intended as a substitute for medical advice or for direct diagnosis and treatment of a medical condition by a qualified physician. Readers who have questions about a particular condition, possible treatments for that condition, or possible reactions from the condition or its treatment, should consult a physician or other qualified healthcare professional.

PORTABLE
COLOUR ME
HAPPY

70 Colouring Templates That Will Make You Smile

Lacy Mucklow, MA, ATR-BC, LPAT, LCPAT

Illustrated by Angela Porter

Race Point
PUBLISHING

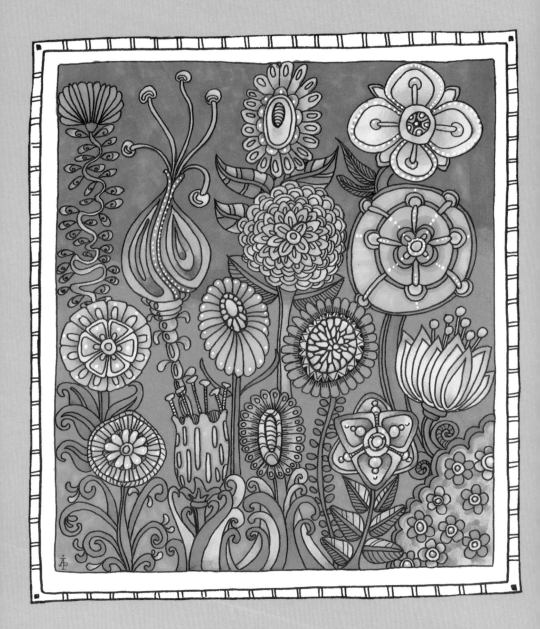

CONTENTS

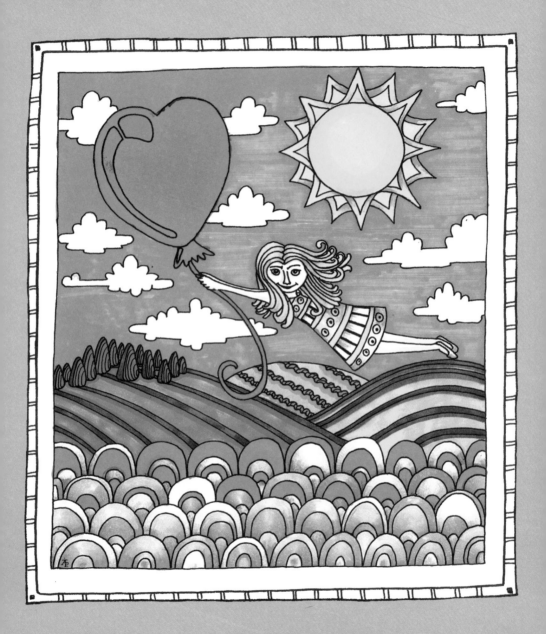

INTRODUCTION

Why make a colouring book for adults? As children, many of us enjoyed colouring in our favorite characters or scenes in books with our trusty pack of crayons, but as we got older, added responsibilities came along, which pushed aside all those things we used to do for sheer enjoyment.

But there is no rule that says we should stop all the fun! One of the great things about colouring is that it is highly accessible for everyone, even if you lack artistic instruction or experience, and it can be as nuanced or generalised as the colourer wishes. Having guidelines eases performance anxiety for many, and being able to add your own colours helps make the experience more personal. The act of colouring can also be fun and meditative in and of itself, bringing about joy just through the simple act of picking up a coloured pencil or crayon and focusing your creativity and thoughts on a single colouring exercise.

Despite what you may have learned about art and colour in your lifetime, there is no right or wrong way to colour, and there is no right or wrong way to use this book; you have the freedom to colour it in however you wish and in whatever way works best for you. Conceptually, in *Colour Me Happy*, the images chosen fall into topics that are universally

found to evoke joyous or upbeat responses in people, such as nature (be it mountains and forests to lakes and beaches), babies and animals (who are often associated with the joy and wonder of innocence), music (which can frequently induce happiness), food and drink (fine dining or home-cooked food can bring enjoyment as well as the memorable gatherings where they are found), whimsical imagery (a different take on the mundane can help us take ourselves less seriously), and various forms of art and architecture (certain styles and topics can be inspirational or can bring about positive feelings upon viewing). The act of colouring combined with the carefully chosen subject matter in this book are meant to work together to create a joyful experience for the reader.

We also realise that what makes people happy can run the gamut even within "universal" categories, so we have included a variety of images within each chapter so that at least some pieces may connect with you personally. The designs are meant for adult sensibility and dexterity rather than for children, and may include actual scenes (or variations thereof) of typically enjoyable subjects, or may simply be more abstract in nature to enjoy the intricacy of the patterns themselves, as many of us do. Even if every image does not speak to you, it will hopefully spark some ideas for you to pursue further and help you be more mindful of using this method as an effective mood-boosting tool. Most importantly, this book is about getting in touch with what makes you feel happy, so if one colouring template does not appeal to you, simply move on to one that does.

At the end of each chapter, a blank panel has been included so that you may have a chance to think about and draw an image that is uniquely

joyful to you—this will make the colouring experience even more personal and will hopefully keep you mindful about things and experiences that you find happy and enjoyable.

You may find that using this book in a regular routine may be particularly helpful for you, such as colouring after a long day to help your body and mind focus on positive things, or perhaps first thing in the morning to get you off to a good start. This book is intended to bring about a happier emotional state as a way to help you combat feelings of negativity, sadness, fatigue, or anxiety; however, it is not meant to replace the services of a professional therapist if more direct intervention and personal guidance are needed. We hope that you enjoy this book and that it helps you find a way to colour yourself happy!

—Lacy Mucklow, MA, ATR-BC, LPAT, and LCPAT

COLOUR TIP

Cool colours (such as blues, greens, and purples) are considered to have calming qualities, while the warmer colours (such as red, oranges, and yellows) have more activating qualities. In addition, bright colours also tend to have more energy, pastel or tinted colours tend to communicate softer energy, while the darker colours or shades usually indicate lower energy. The most important thing when colouring is to figure out which colours you find energizing, and then try to incorporate them into your artwork.

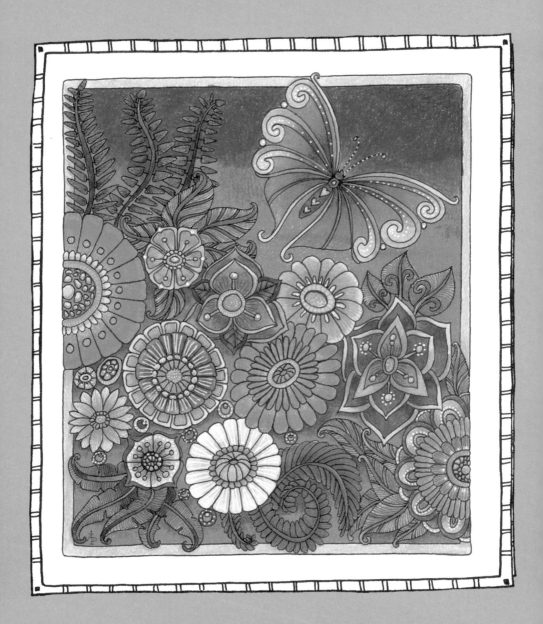

Chapter 1

NATURE

The types of images that boost people's moods can vary greatly, but there are several universal images that make people happier when they think about or see them, including those of nature. Thinking about the simplicity and basics of the natural world, especially when caught up in the stresses of an urban lifestyle, can bring contentment and feelings of gladness. Natural phenomena and creations, such as sunrises and sunsets, snowflakes, rainbows, and flowers, can bring a sense of awe in people with their beauty. Environments near water or where one can enjoy the sun are known mood boosters, and this can include engaging in or viewing representations of outdoor activities, such as hiking or scuba diving. In this chapter, natural images are included for you to colour in ways that are pleasing to you. Contemplation of these pictures while colouring them can bring about positive feelings as you continue to engage with them and make them personal to you. At the end of this chapter, there is a blank panel for you to draw and colour your own image of something you find particularly happy in nature.

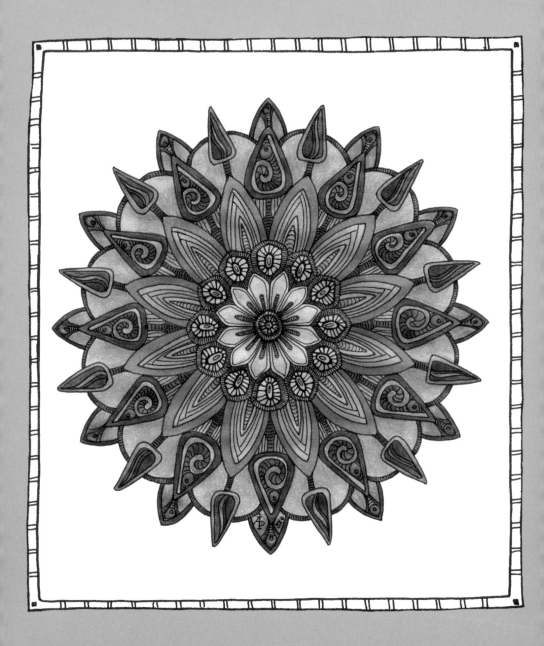

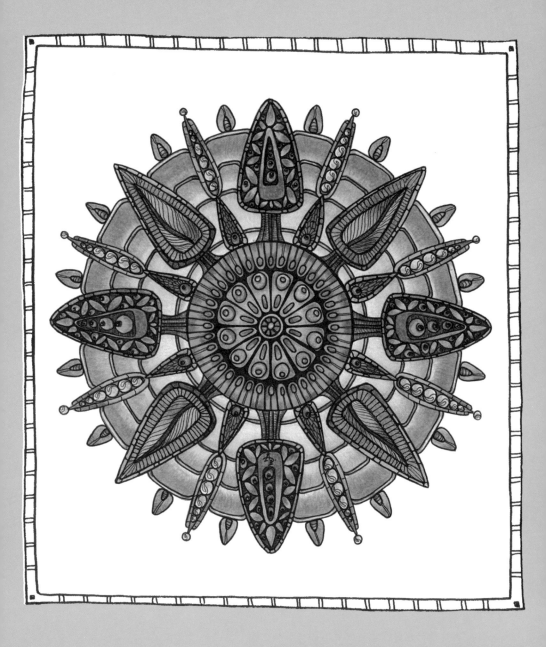

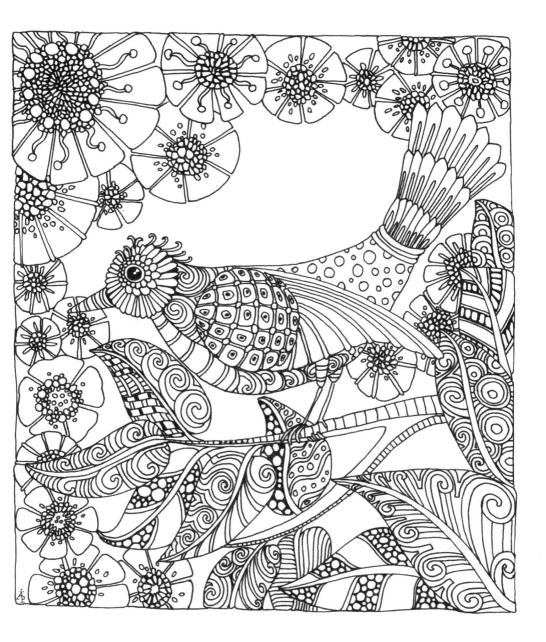

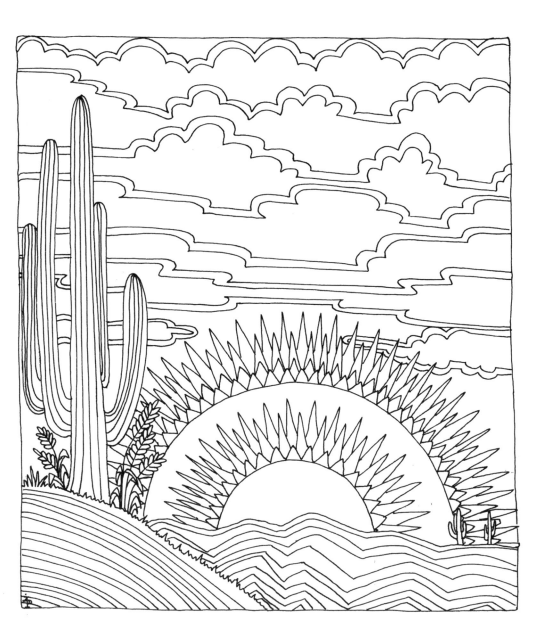

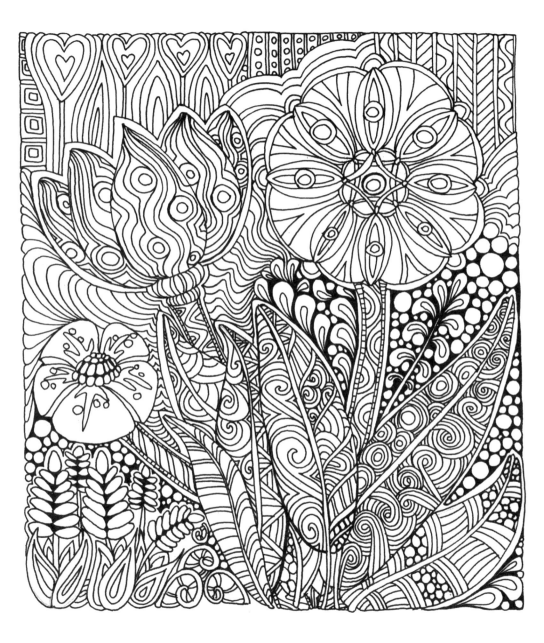

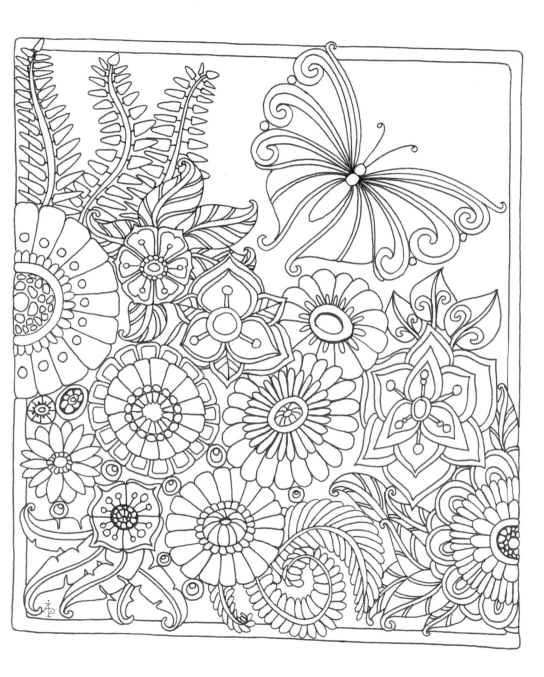

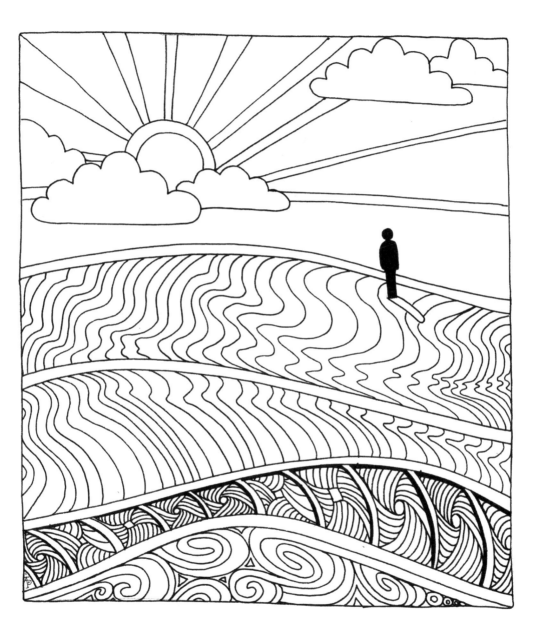

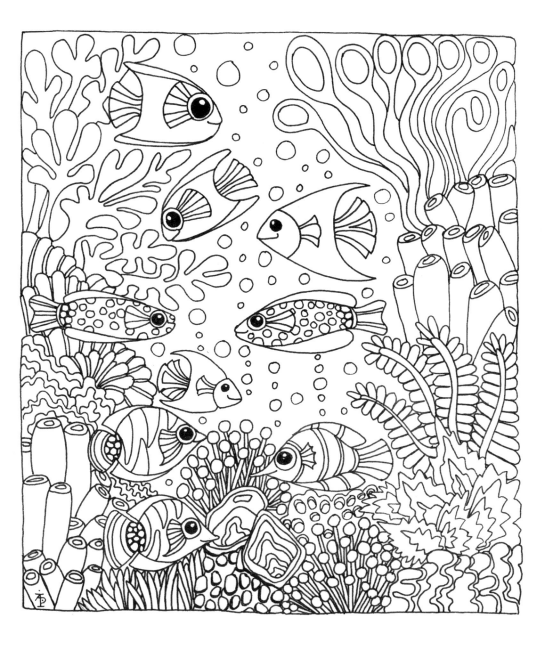

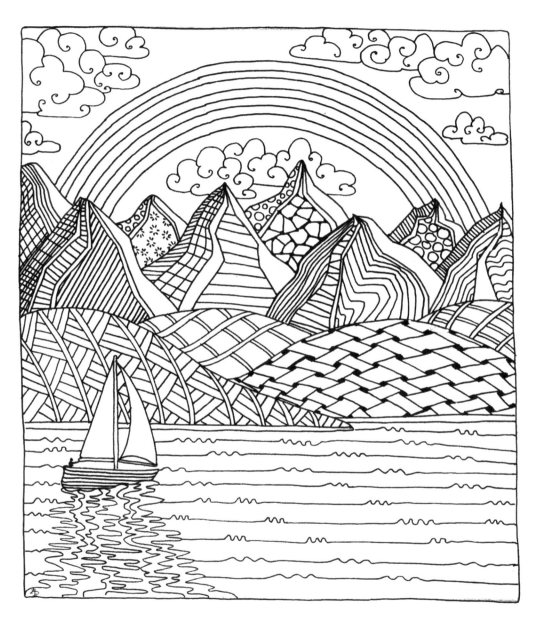

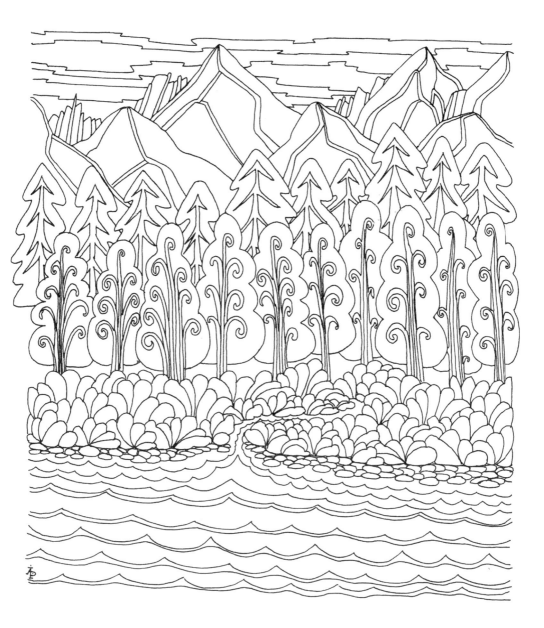

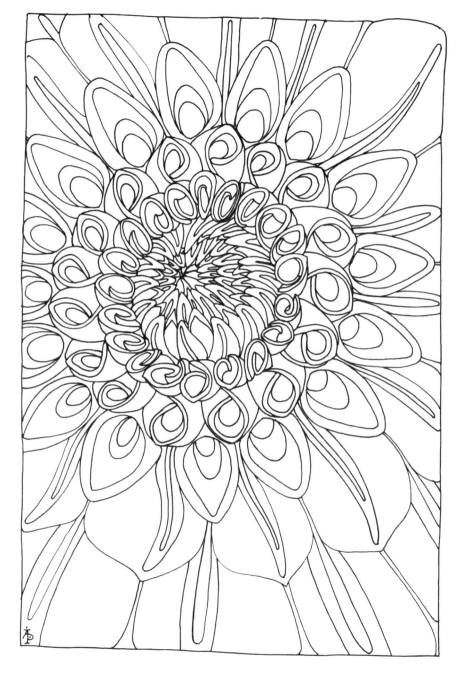

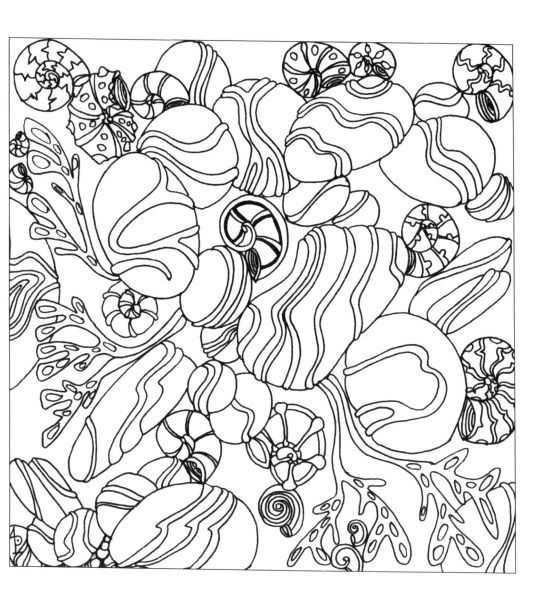

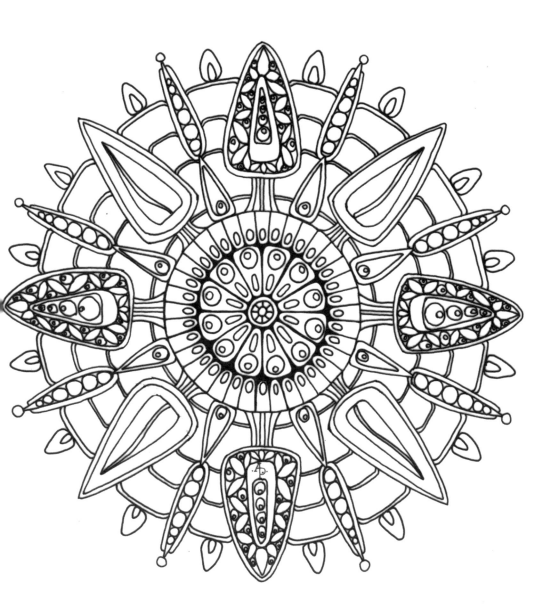

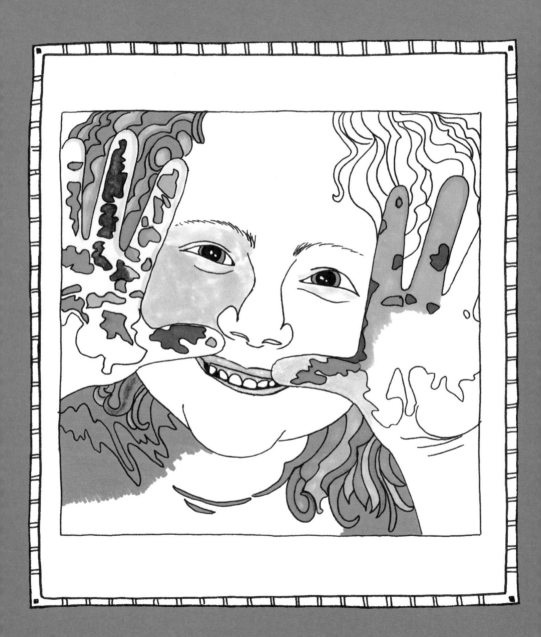

Chapter 2

ANIMALS & BABIES

When viewing a young child or baby animal, we tend to respond with a nurturing reaction, which often elicits a positive feeling. When we see young of all kinds in times of joy themselves, those images can also influence our mood, for the better, with their infectious expressions of happiness. The candidness and carefree nature of children or the lack of coordination seen in baby animals when adjusting to their environment can also lighten the mood and cause us to chuckle, even when captured in an image. Recent research has even shown that not only does viewing pictures of cute animals increase our "warm and fuzzy" feelings, but it also increases work productivity and concentration. In this chapter, you will find images related to youngsters in carefree moments. You may decide to colour them related to children or animals you know in your own life, or you may want to experiment with colour to make them unique and fun. At the end of the chapter is a blank panel for you to draw and colour a related image that is special to you.

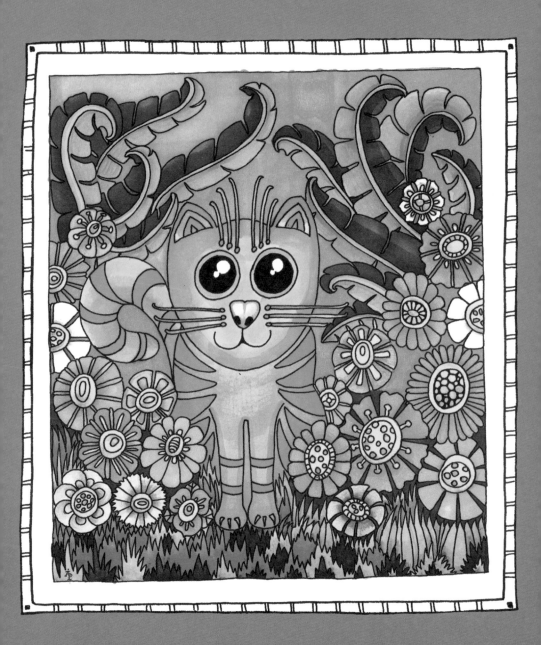

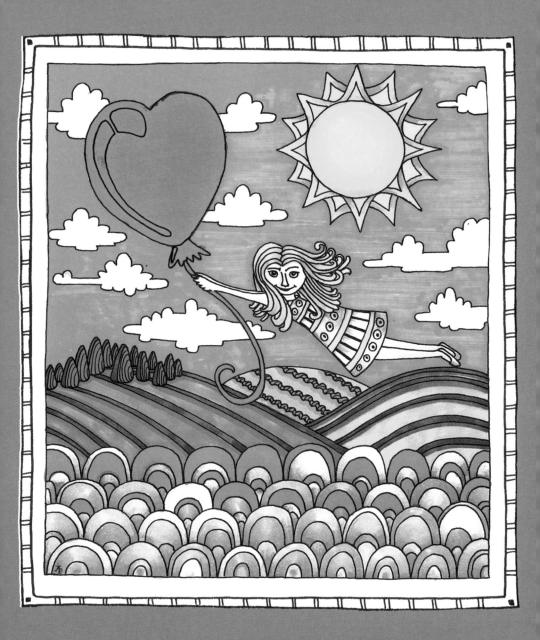

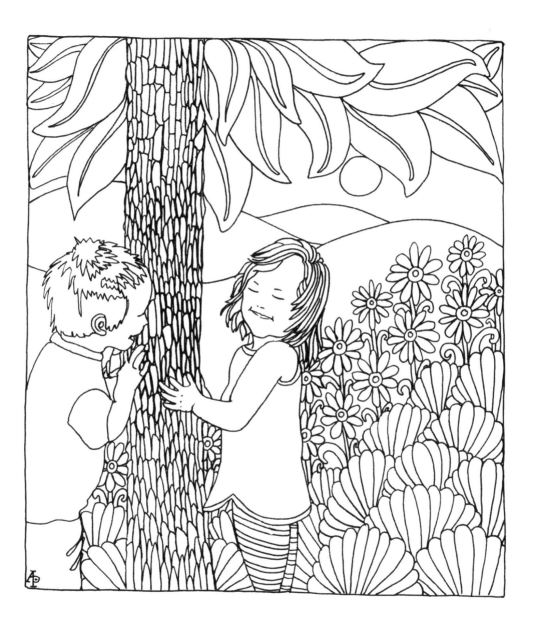

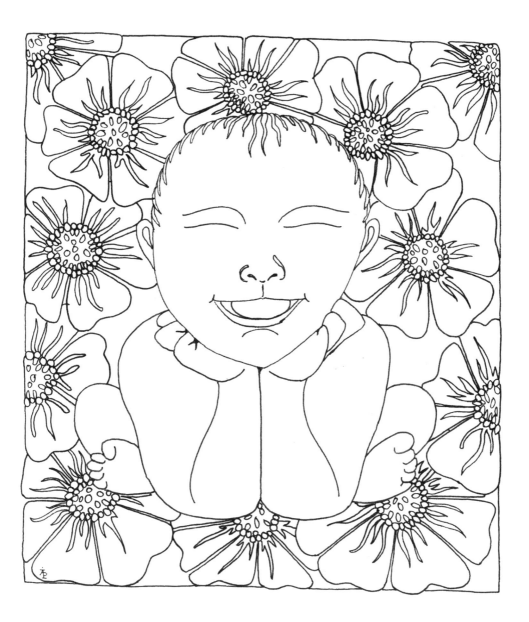

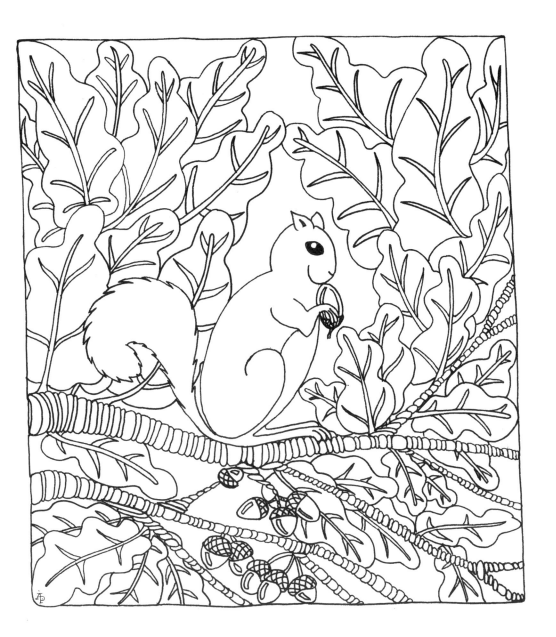

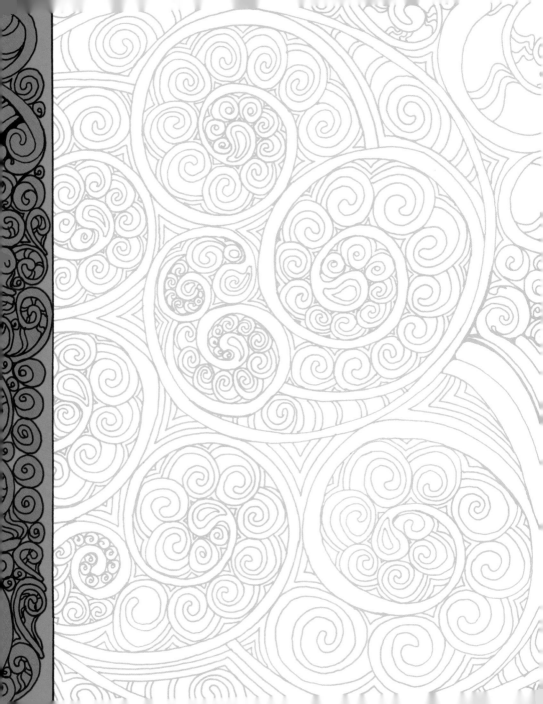

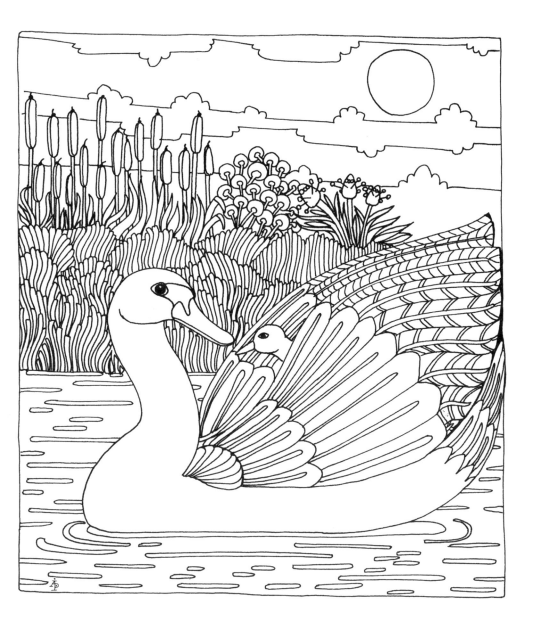

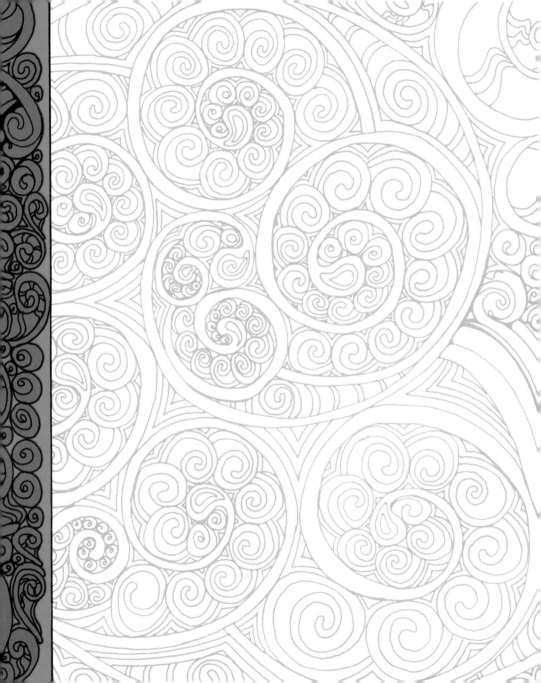

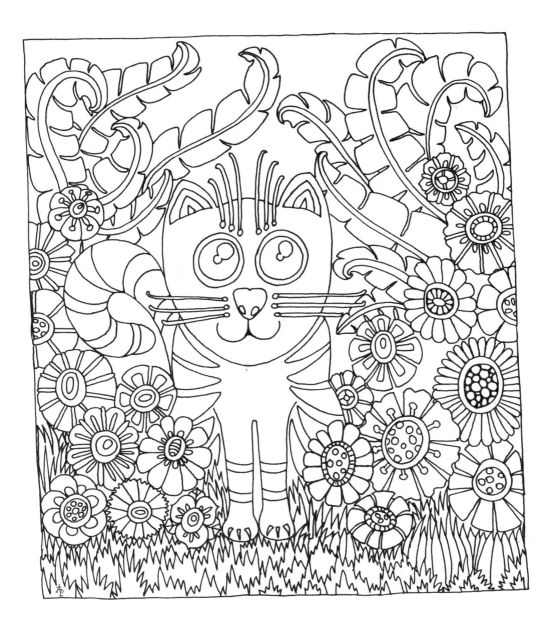

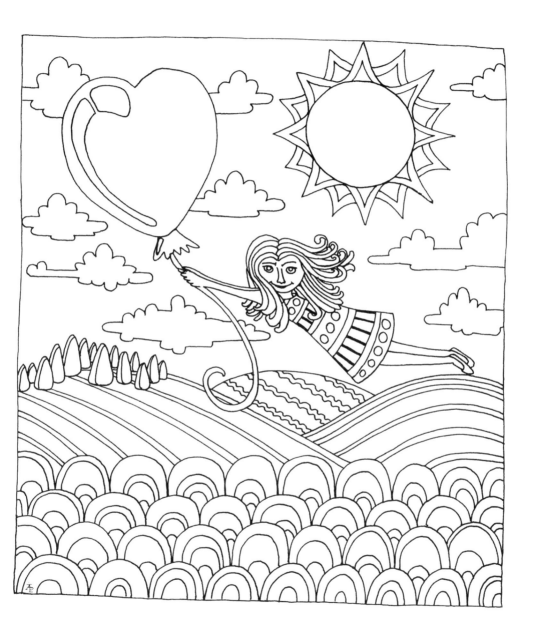

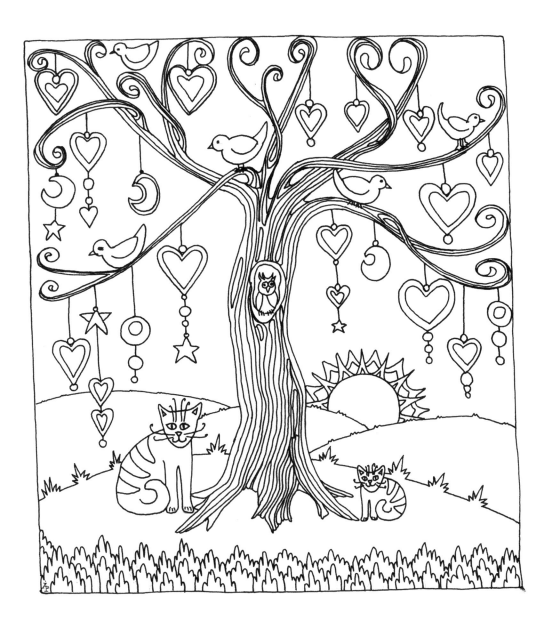

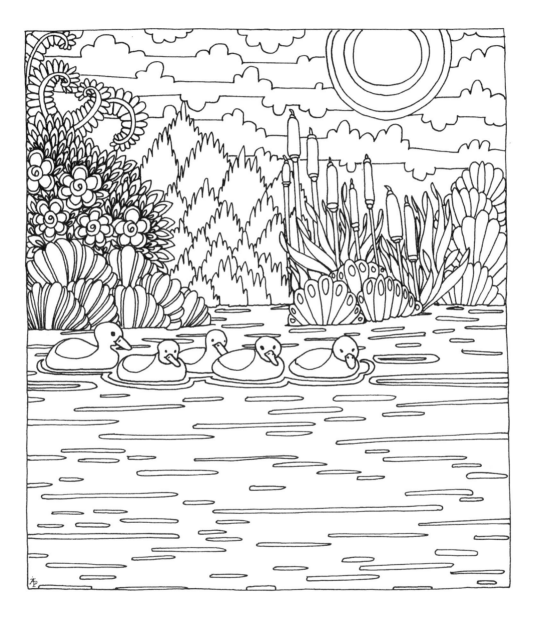

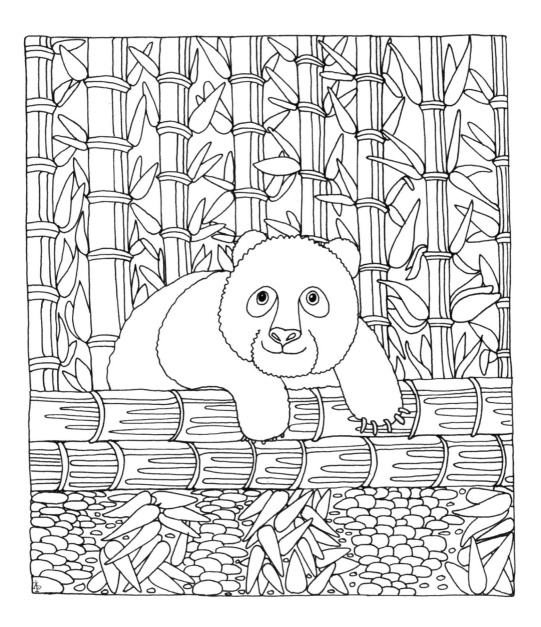

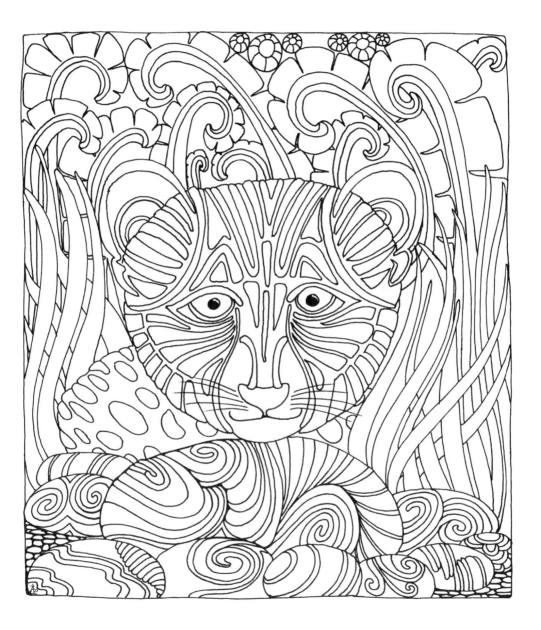

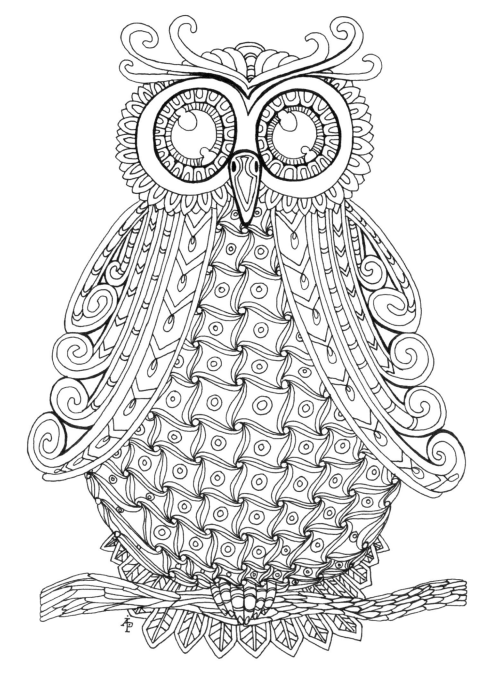

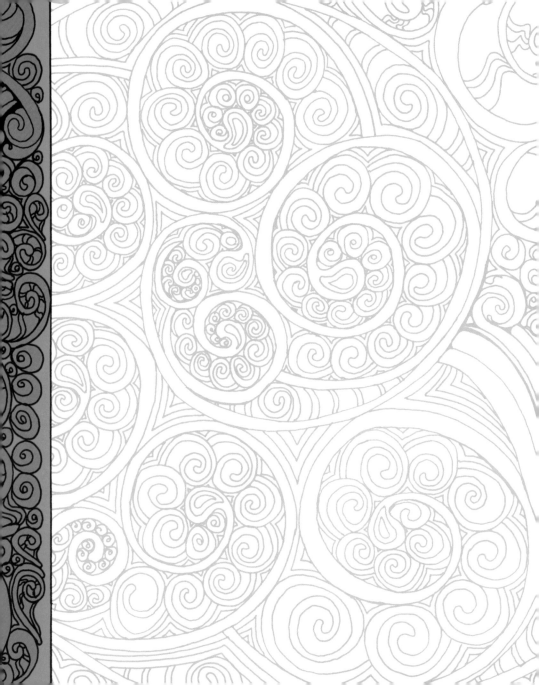

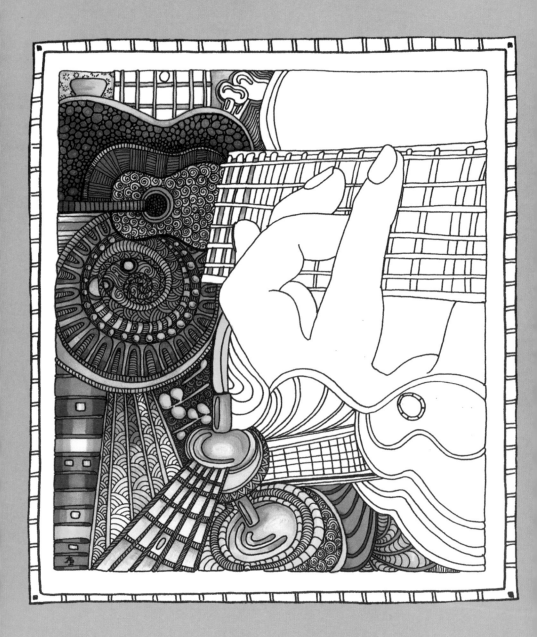

Chapter 3

MUSIC

From a primitive drumbeat to a complex orchestral symphony, music of all kinds has permeated the psyche and emotions of people for thousands of years. Most people partake in music, solitarily or in a group, because they find enjoyment in it, whether it is listening to an album, attending a concert, or playing in a band. We listen to or play music to express how we feel, and a simple melody, lyric, rhythm, or beat can help elicit a positive feeling that we most associate with the music we love or with which we have a positive connection, improving our mood. In this chapter, there are several images that represent music, whether instrumentally, symbolically, or representationally. Perhaps certain ones will evoke a particular happy memory or experience for you while you are colouring them in. At the end of the chapter is a blank panel for you to draw and colour musical imagery that inspires a positive feeling in you.

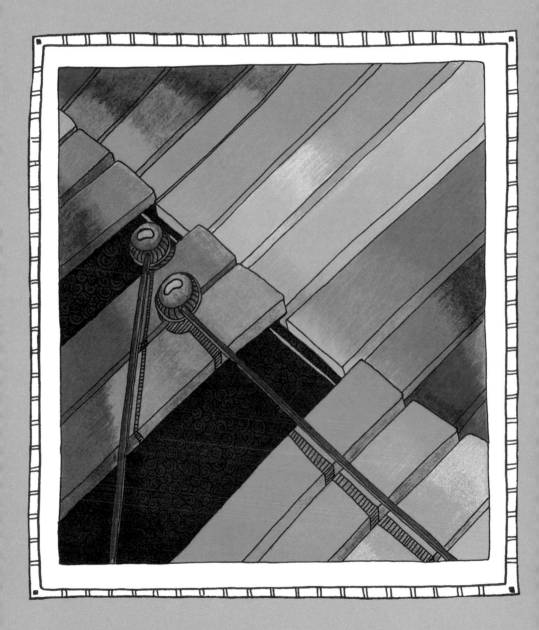

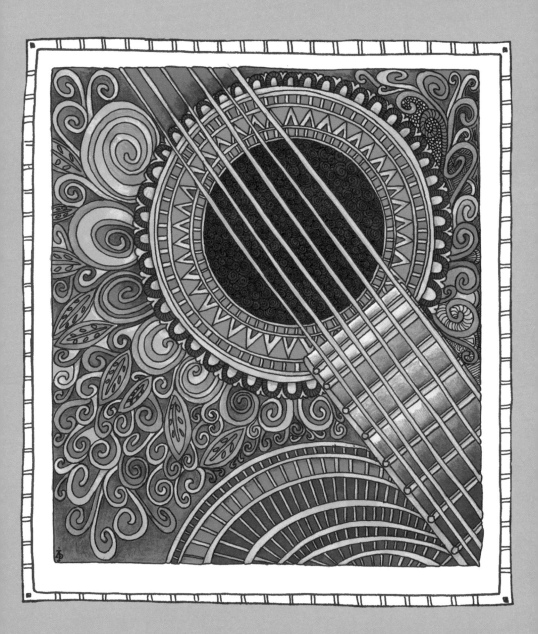

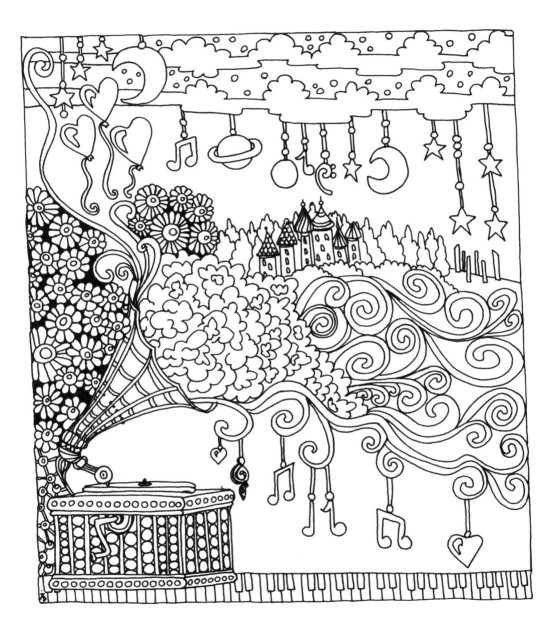

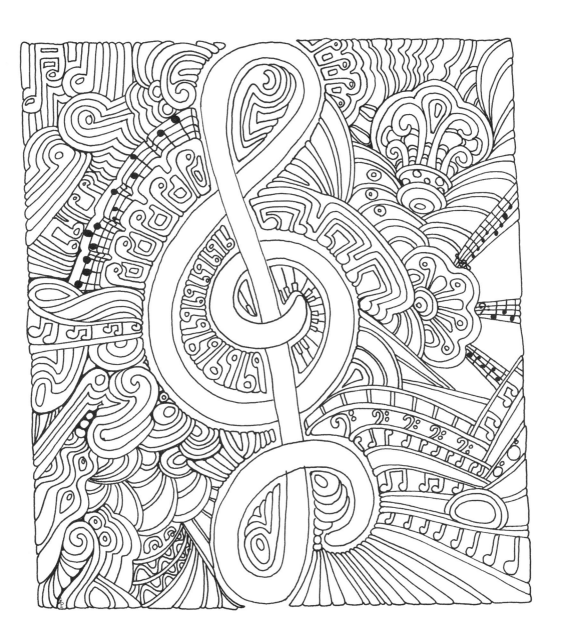

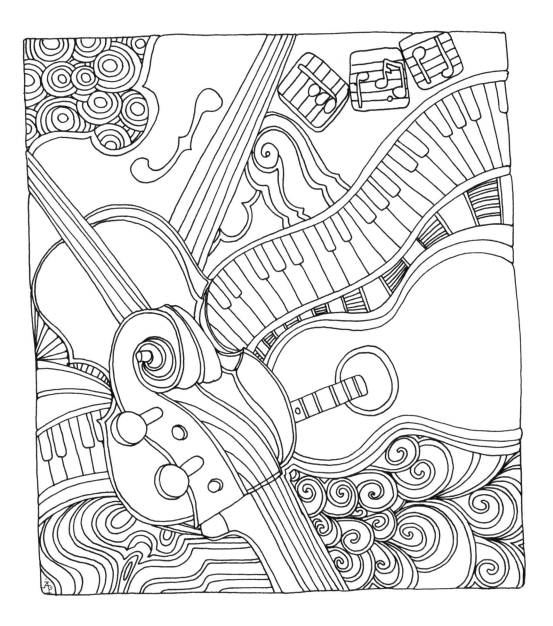

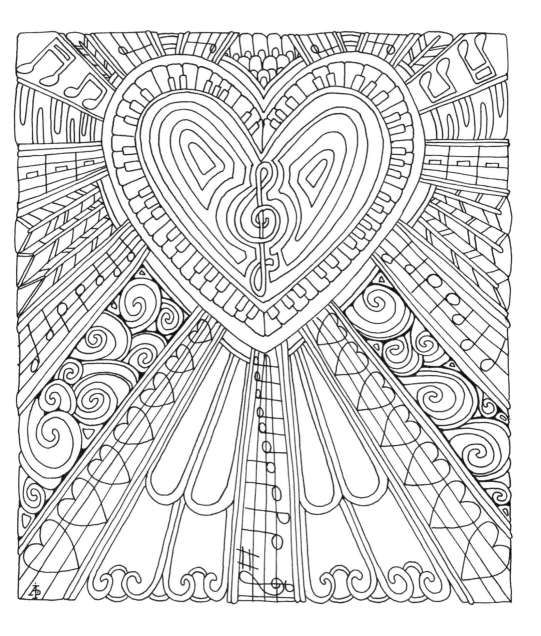

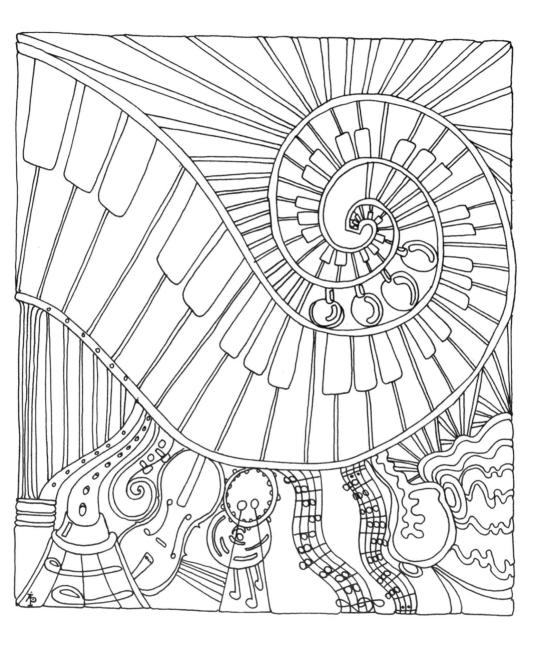

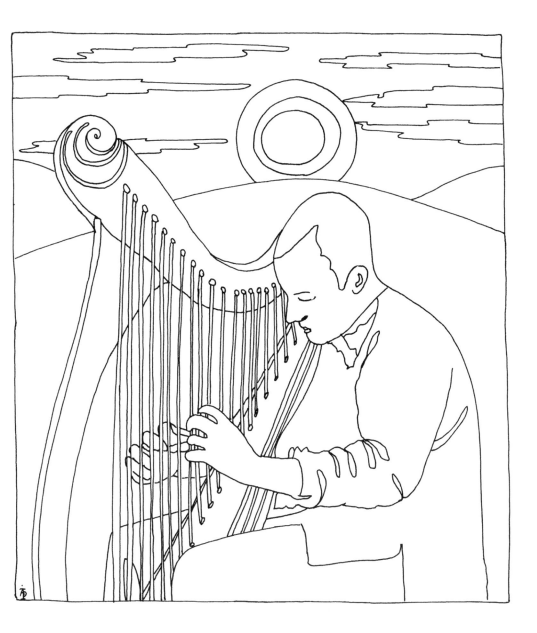

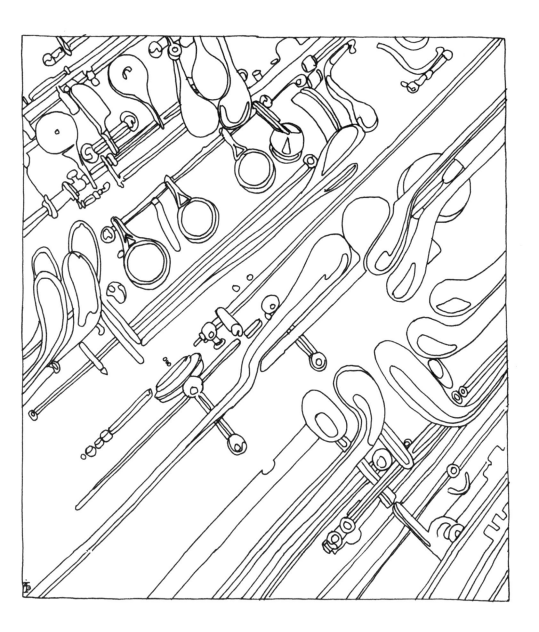

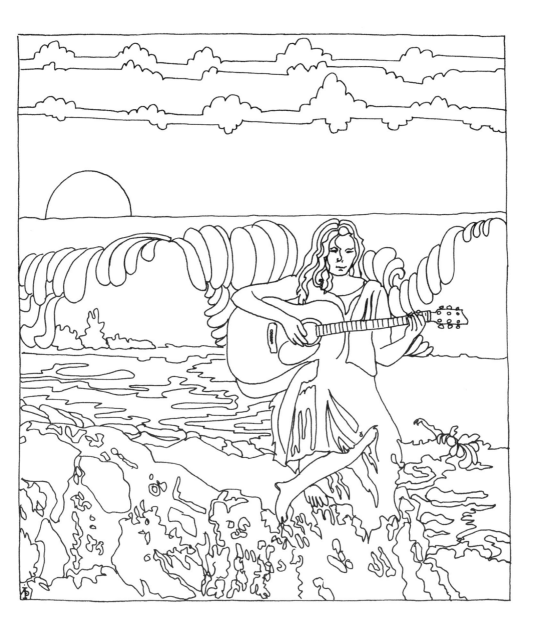

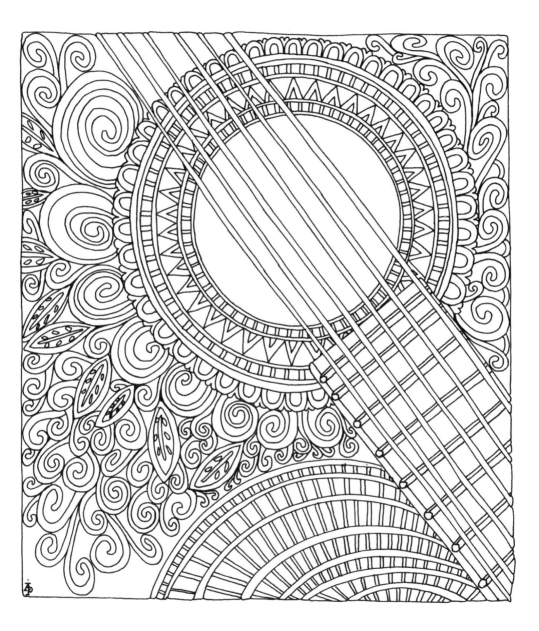

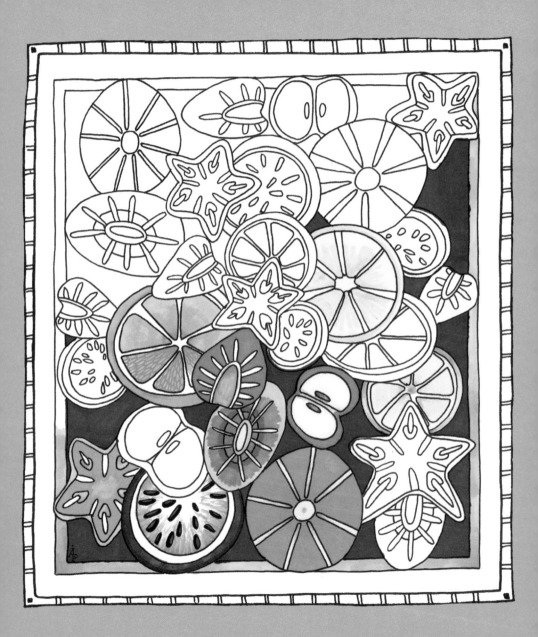

Chapter 4

FOOD & DRINK

For thousands of years, food and drink have been at the center of celebrations, whether it be among close family and friends or large gatherings to commemorate birthdays, weddings, sporting events, rites of passage, or other special occasions. Comfort food in particular is associated with helping one feel good. It may be something that is soothing in and of itself, such as soup, or something associated with a positive memory from childhood, such as a special birthday cake. Specific foods can also have a direct impact on mood by increasing the pleasure chemicals in the brain. Protein, caffeine, omega-3 fatty acids, tyrosine, glutamine, gamma-aminobutyric acid (GABA), and cortisol (or its activators) are just a few of the components in certain foods that may improve one's mood. Included in this chapter are a number of images to colour depicting various foods and drinks that are commonly associated with positive feelings. A blank panel is included at the end of the chapter to encourage you to draw and colour edibles that are special to you.

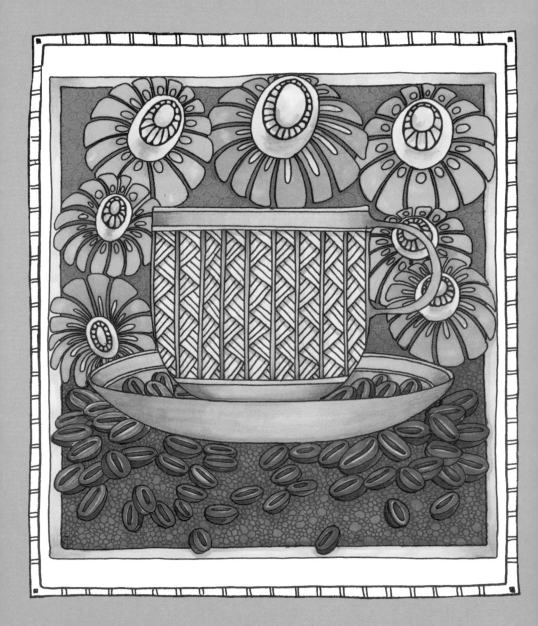

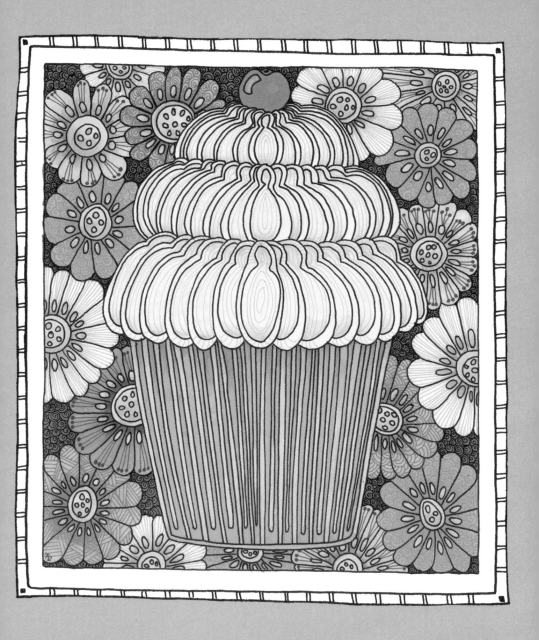

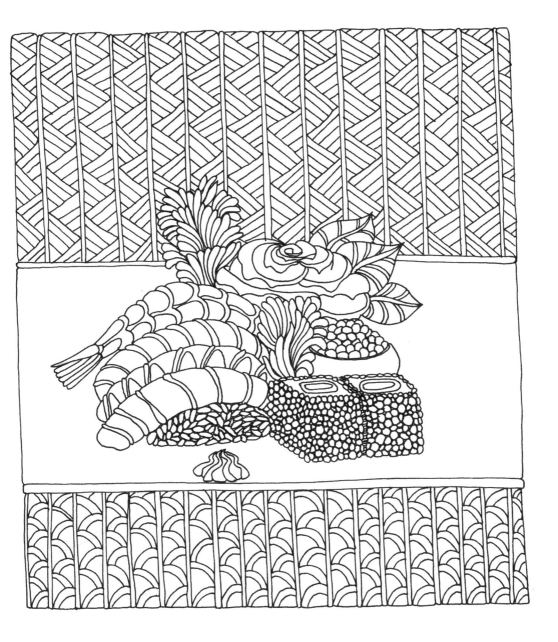

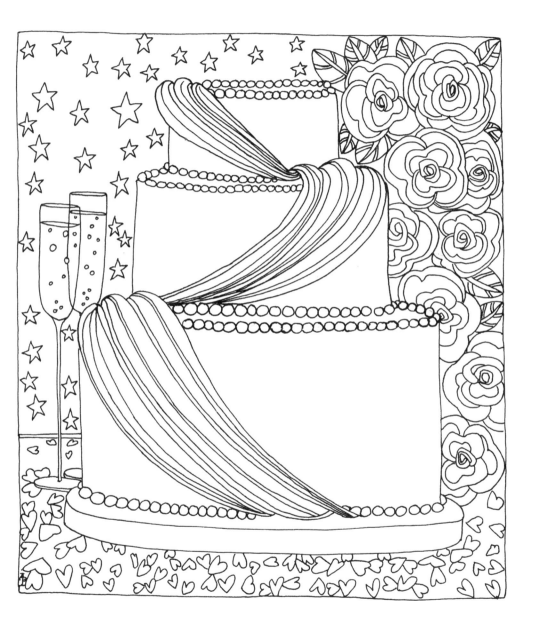

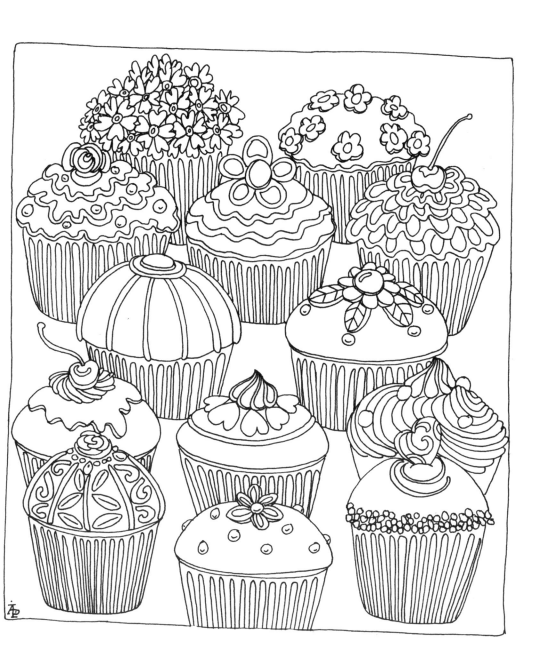

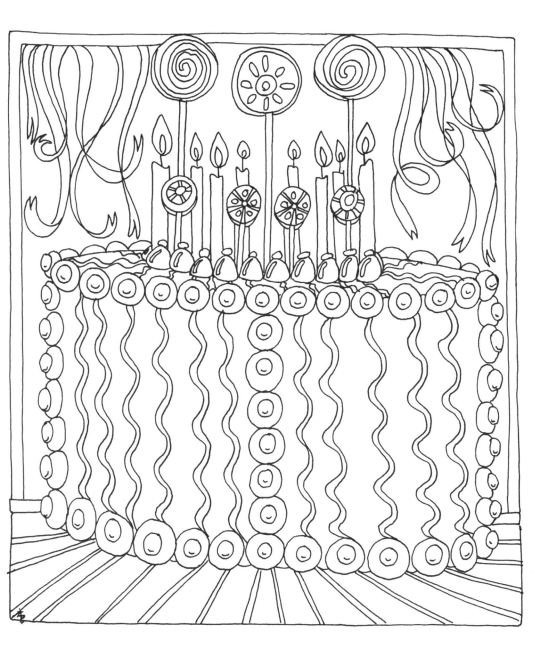

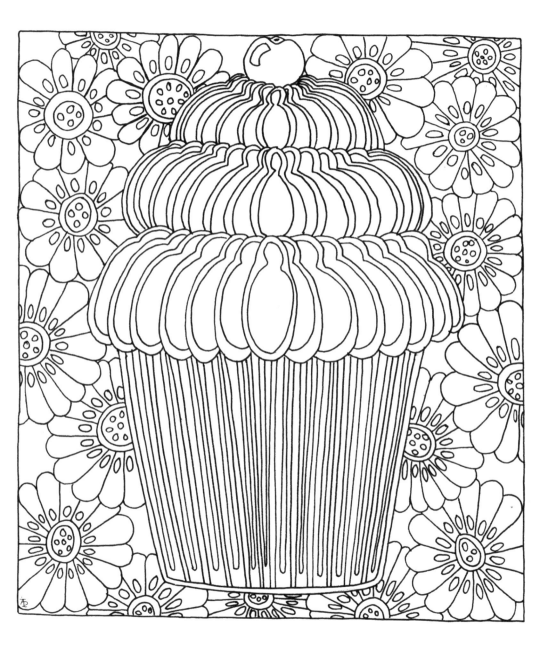

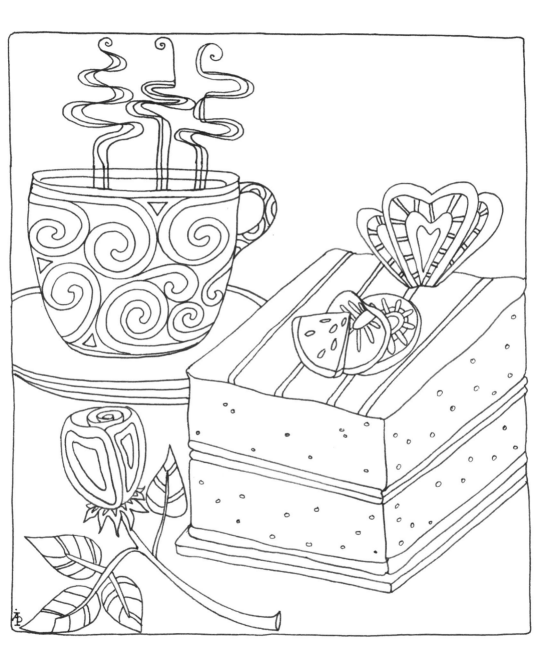

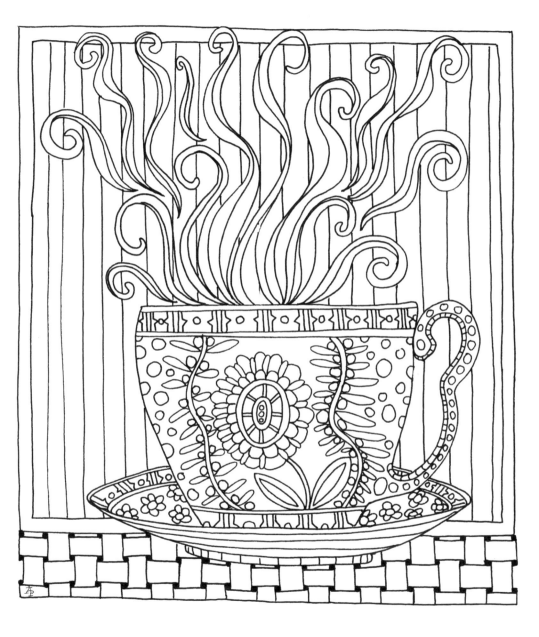

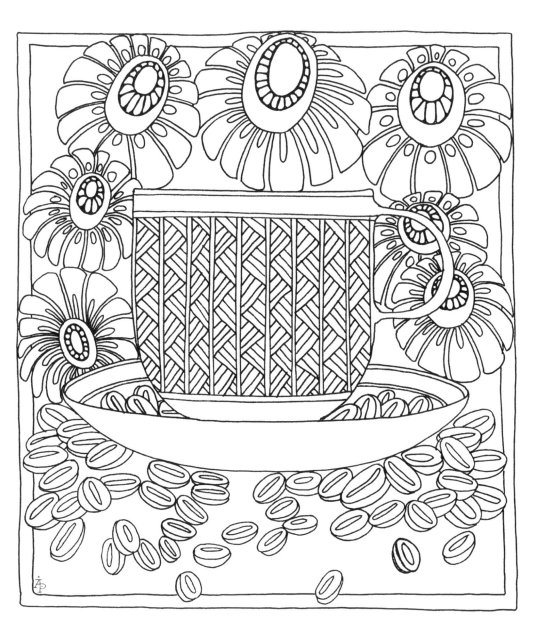

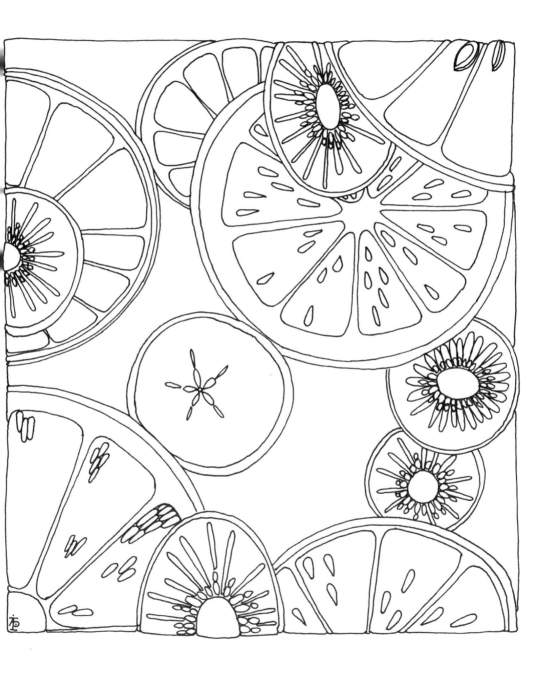

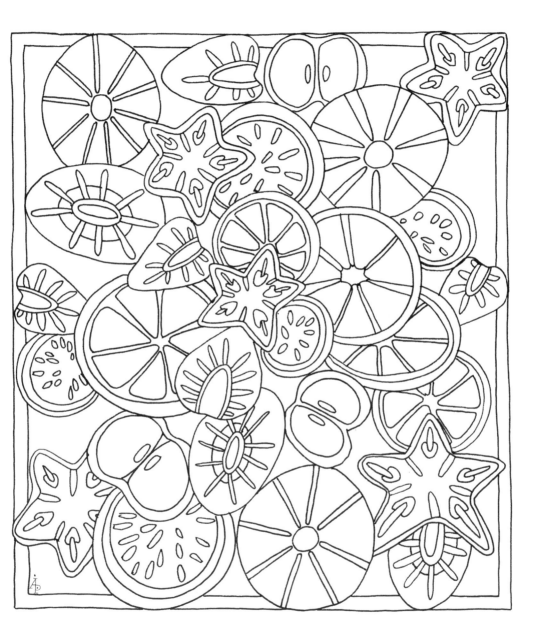

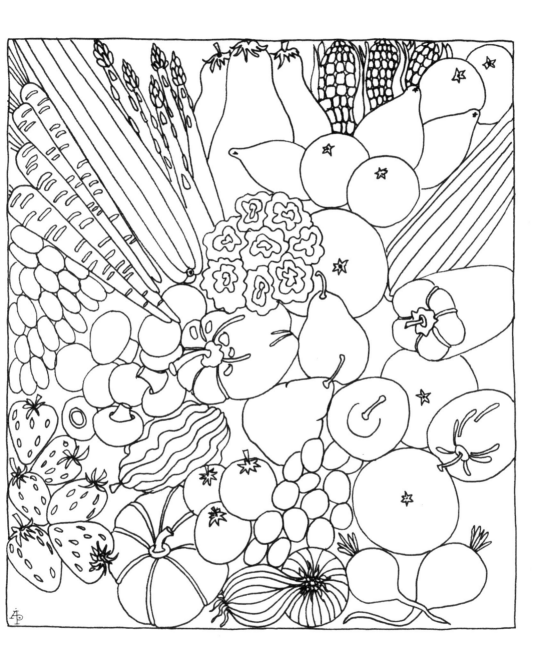

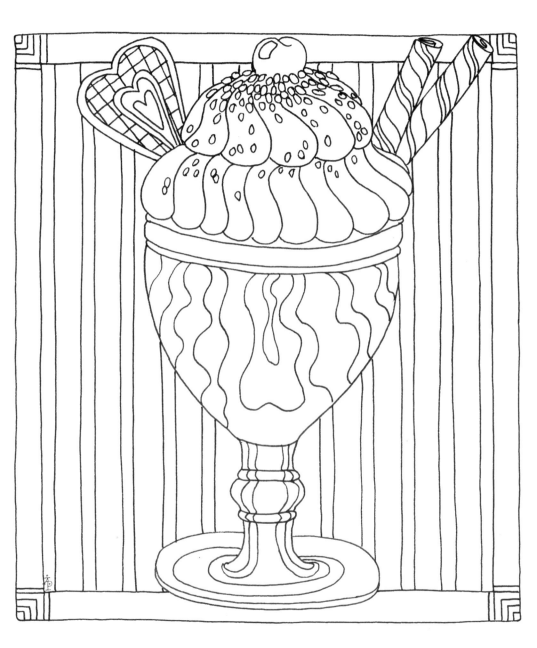

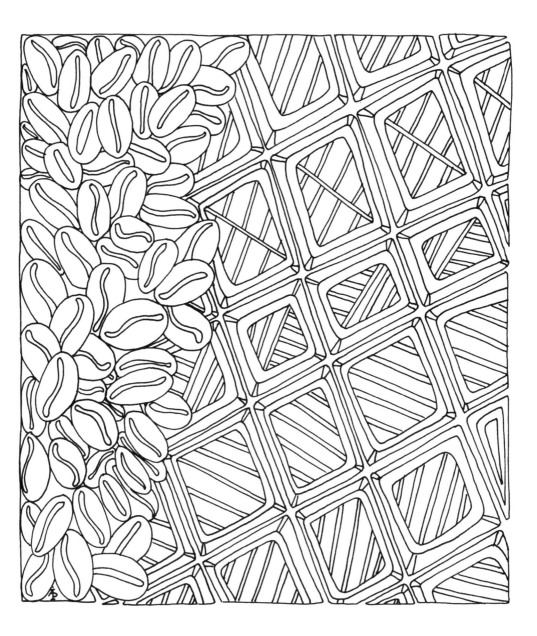

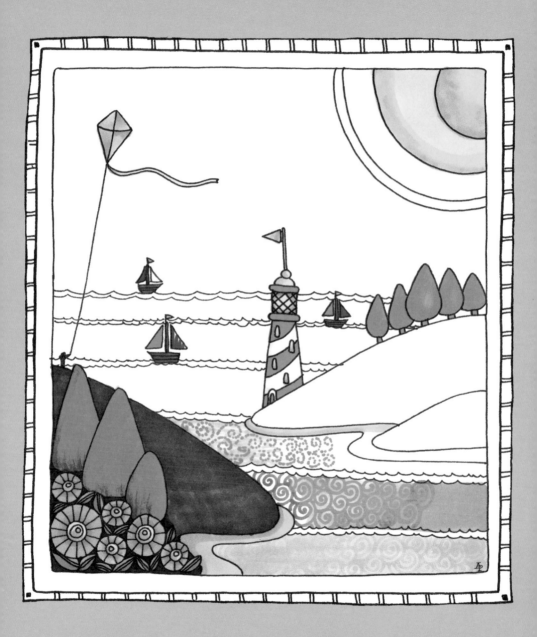

Chapter 5

WHIMSICAL IMAGERY

Whimsical images naturally make us smile and are meant to inspire joy, lightheartedness, and unrestraint. These images are out of the ordinary, so enjoying them can give one a break from the status quo. Whimsical images are often brightly coloured, which can also boost one's mood. Taking everyday objects and transforming them into something stylised, abstract, patterned, or downright peculiar can keep life interesting and fun. Throughout this chapter, you will find whimsical images that may or may not make sense to the sophisticated eye, but may speak to your inner playful self and evoke positive feelings. As you colour, use hues that you feel exemplify the whimsical nature of the images and that personally increase your sense of happiness and pleasure when looking at them. A blank panel is included at the end of the chapter to encourage you to draw and colour your own whimsical picture.

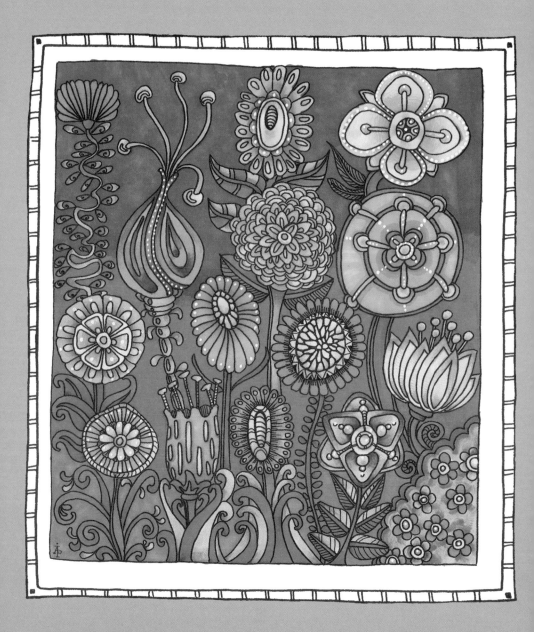

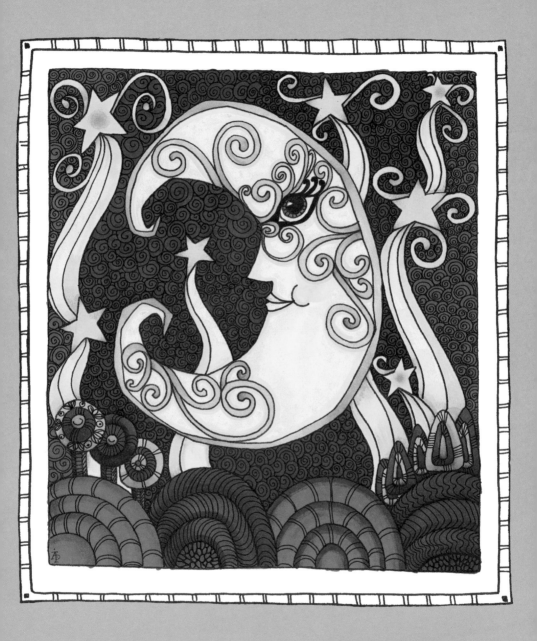

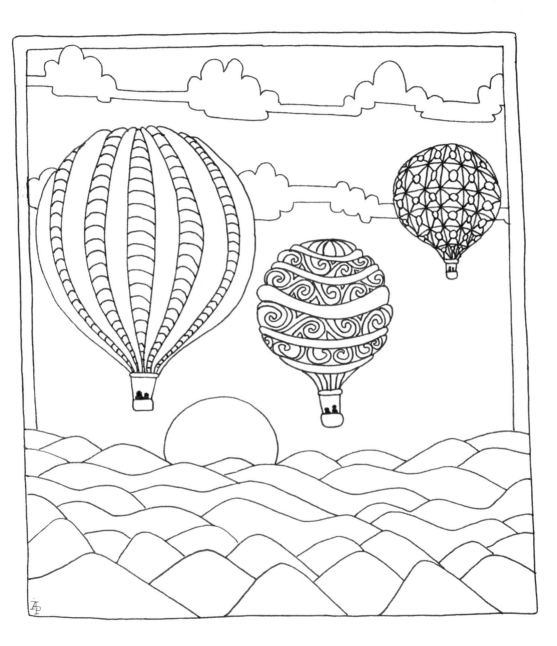

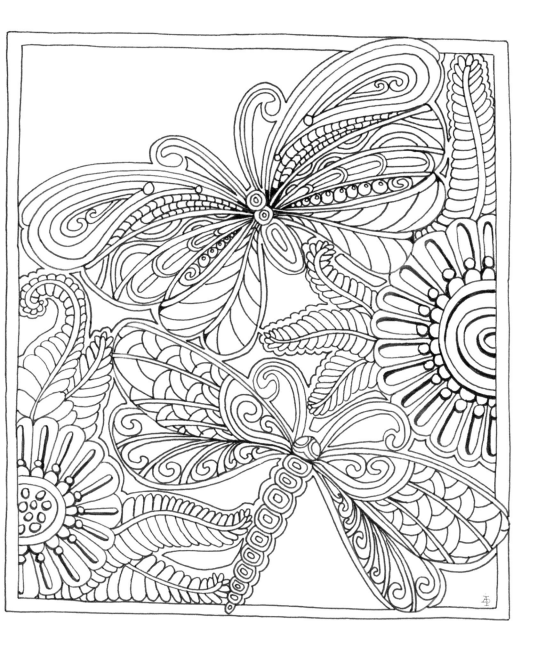

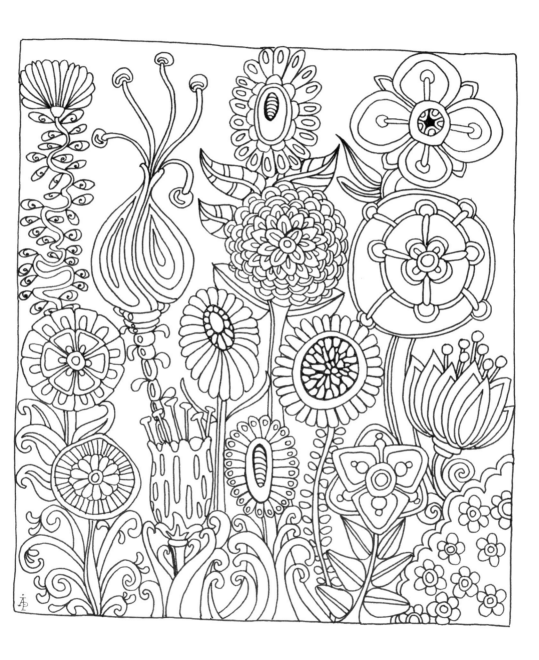

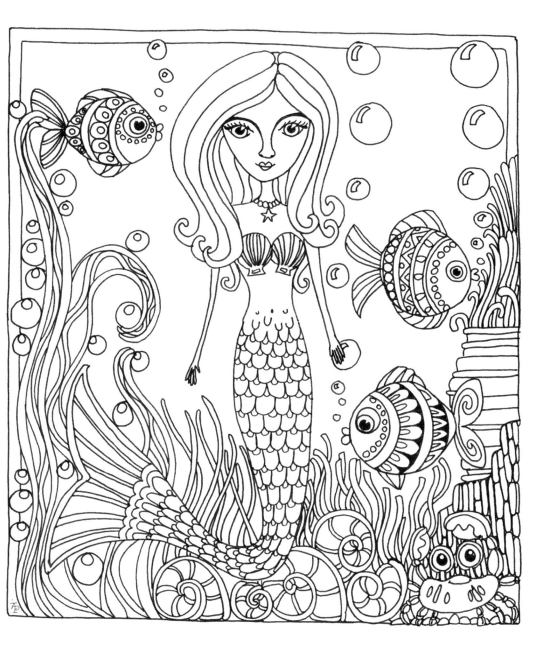

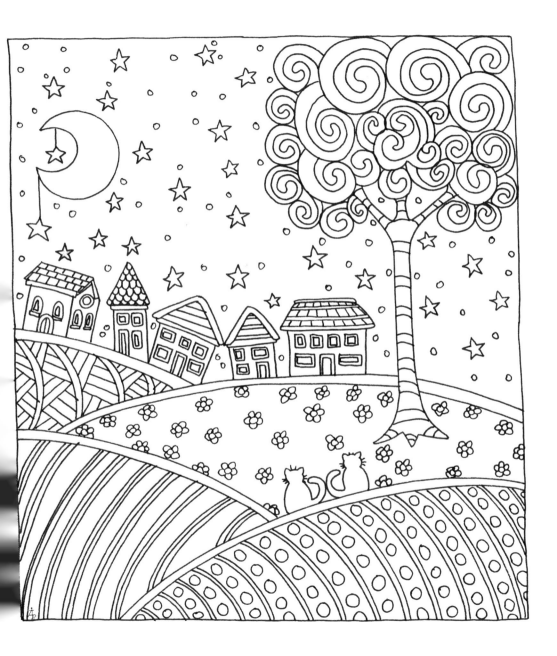

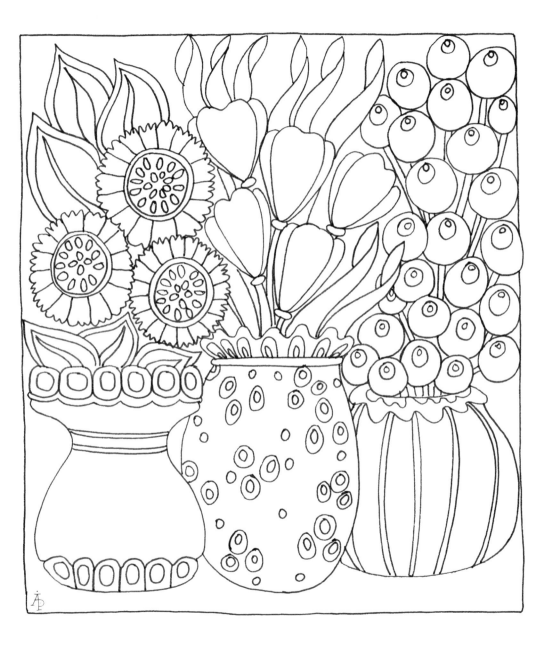

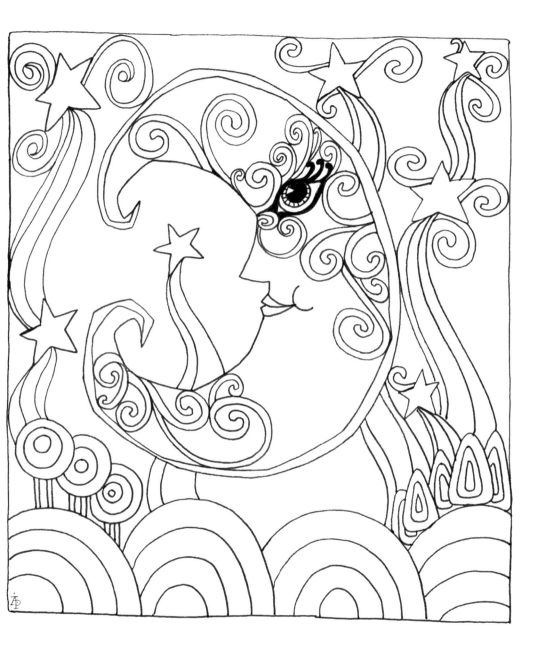

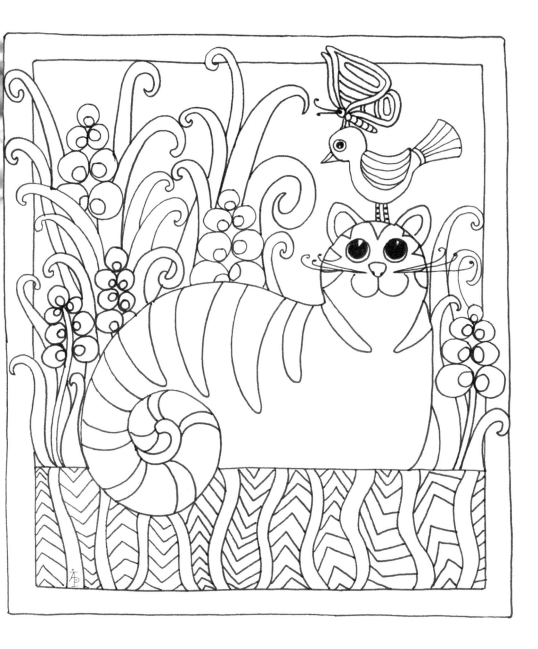

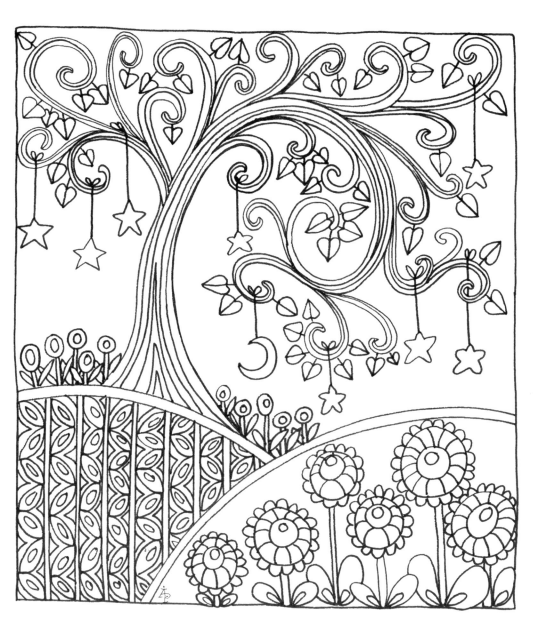

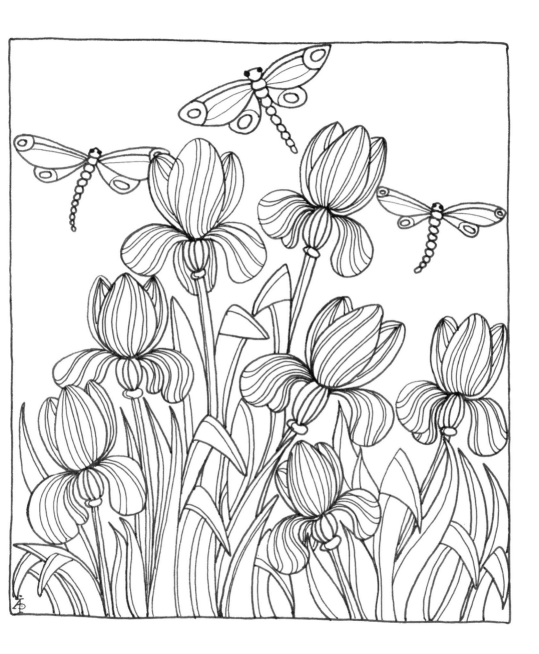

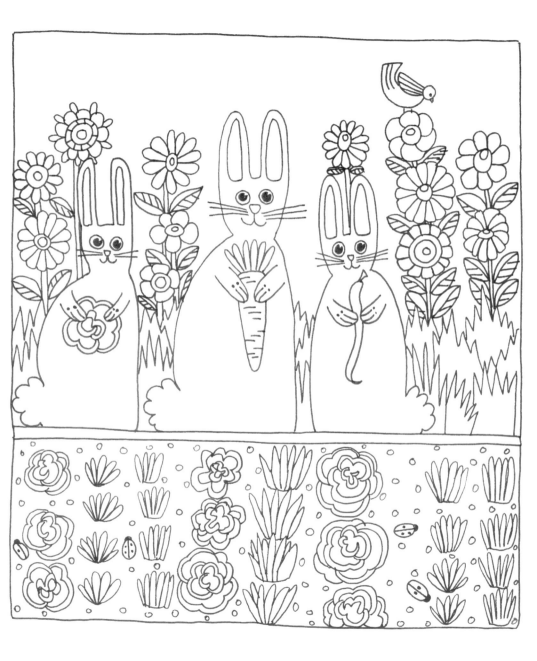

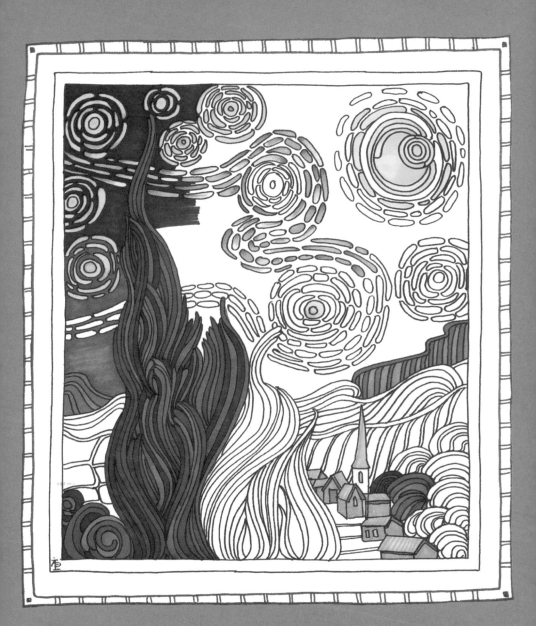

Chapter 6

ART & ARCHITECTURE

Throughout history, mankind has created art and architecture not only for practical purposes, but also as a means to share innovation and reflect its cultural foundations. Certain buildings and works of art, classical and contemporary, can evoke a happy feeling or even inspire a sense of awe or pleasure when viewed. The palette used in an artwork or the colour scheme of a building, as well as the actual composition of the building itself, can affect one's mood. What one considers joyful or inspiring art or architecture is subjective, but there are general ideas, designs, images, and subjects that are universally pleasing. As you consider colouring the following designs, you may choose to stick to a traditional colour scheme, or you may want to add your own innovations through personal colour choices. There is a blank panel at the end of this chapter to encourage you to draw and colour a work of art or architecture that you find particularly pleasing.

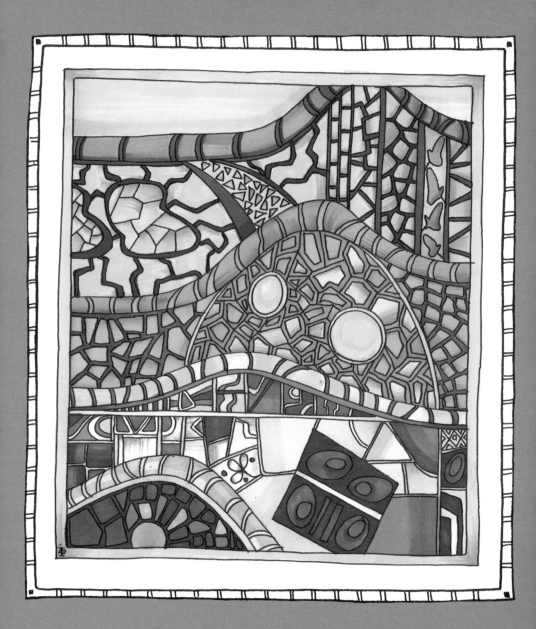

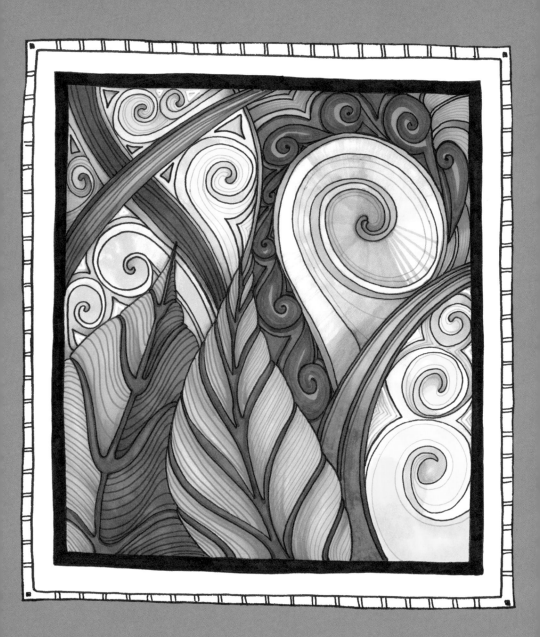

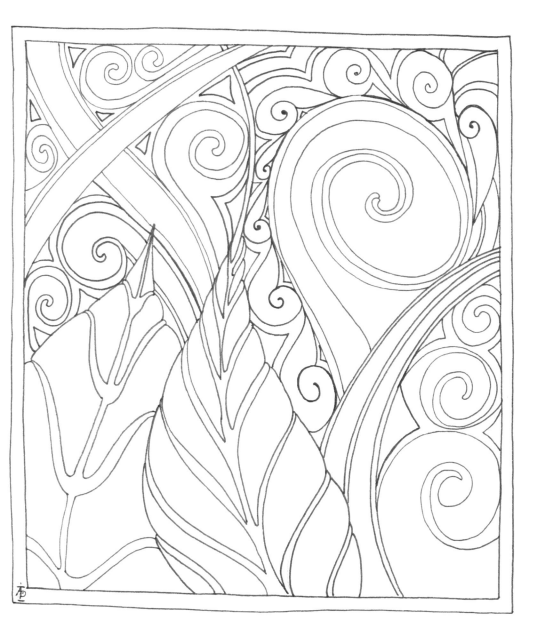

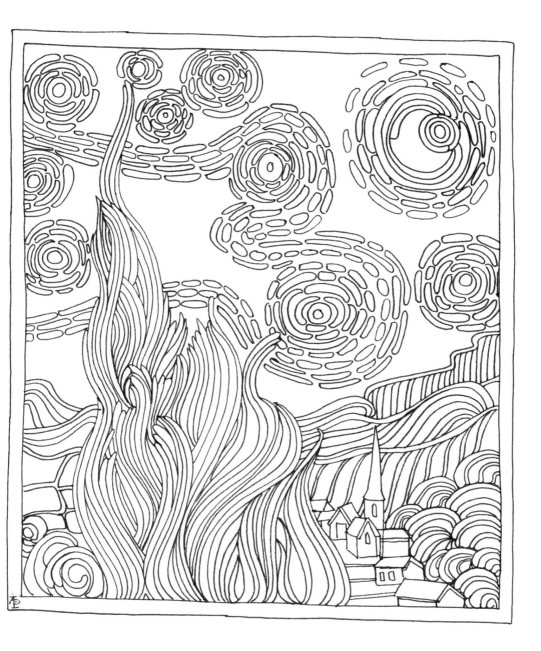

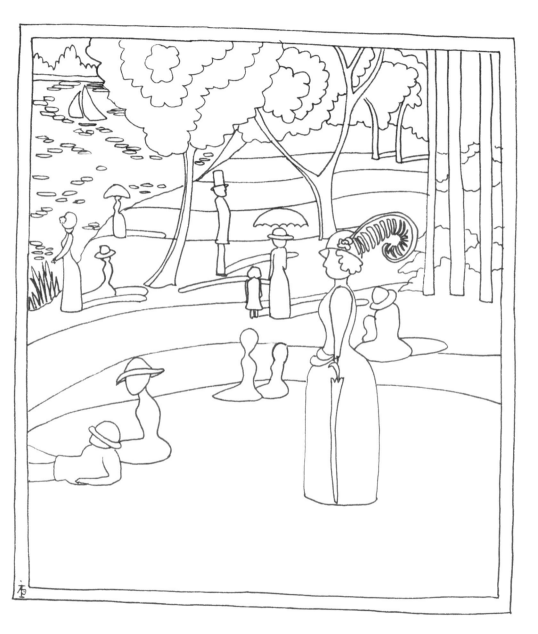

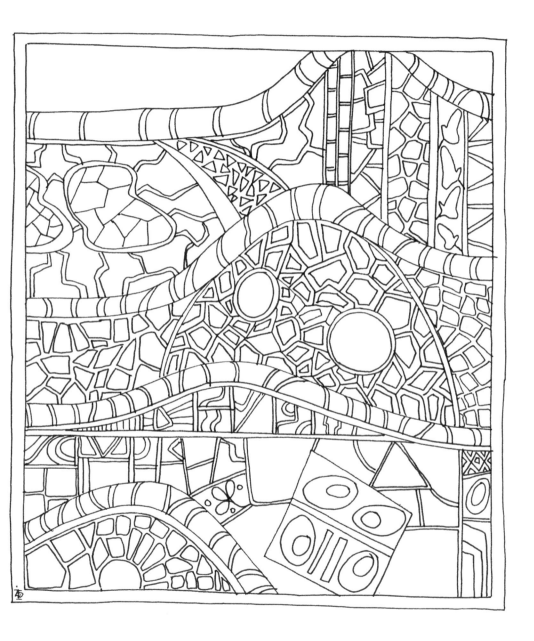

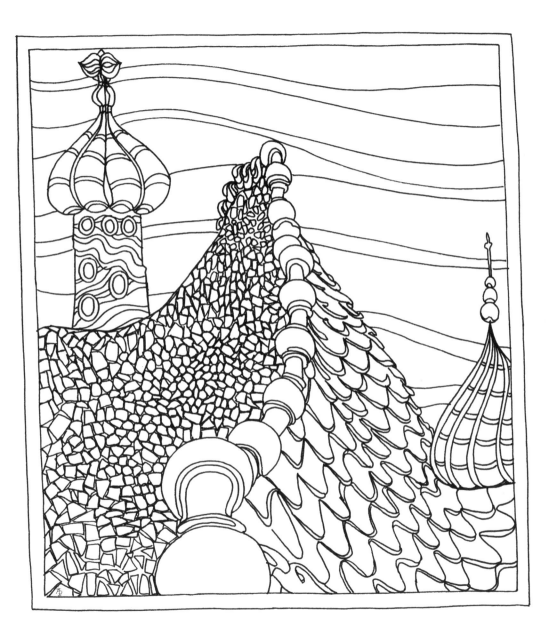

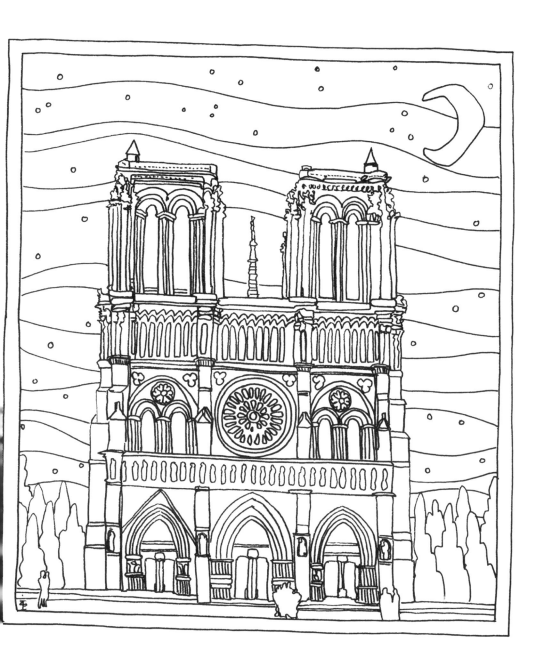

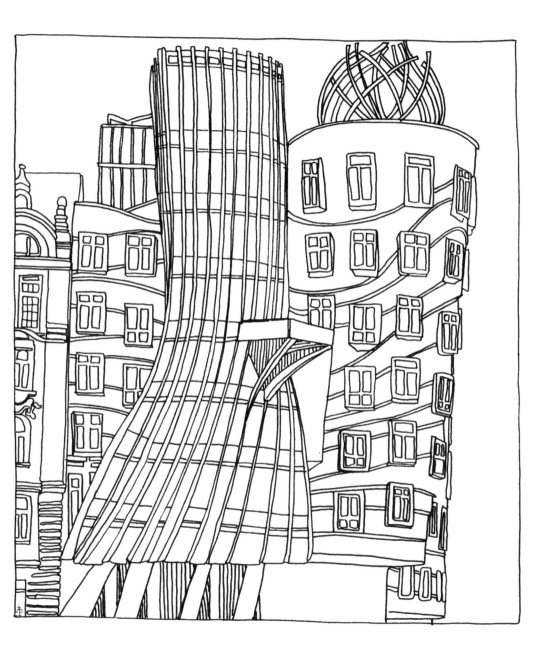

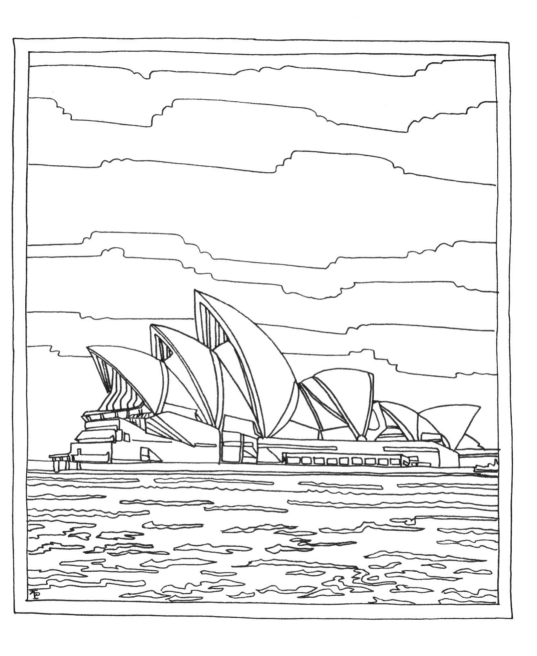

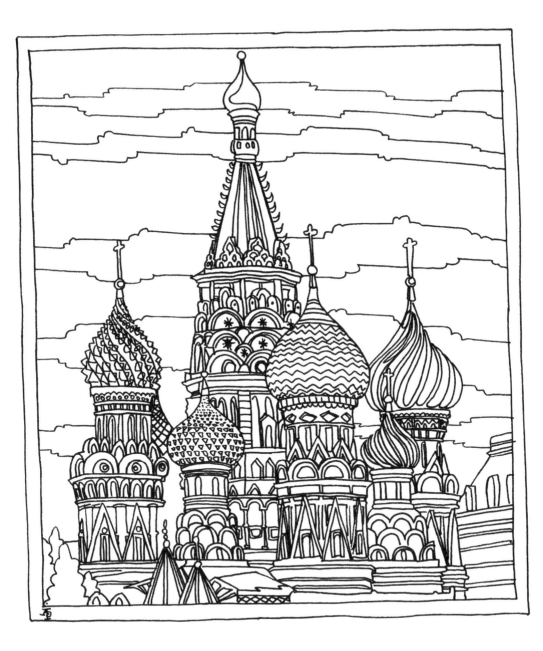

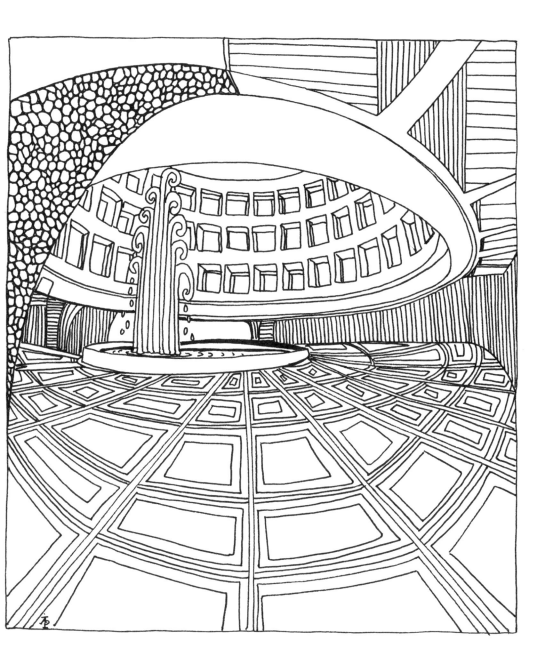